Open Ward Activity (Weekends Only)
Closed Ward Activity (Weekends Only)
Closed Ward Activity/Movie
Open Ward Wrap Up
Closed Ward Wrap Up

dicehouse

chemicals we put in our bodies are just

sucking hopelessness

the way that we live, have society/civilization set up, is making a lot of us sad, depre[ssed,] frustrated people. this just makes life a little more bearable, a little less miserable

green

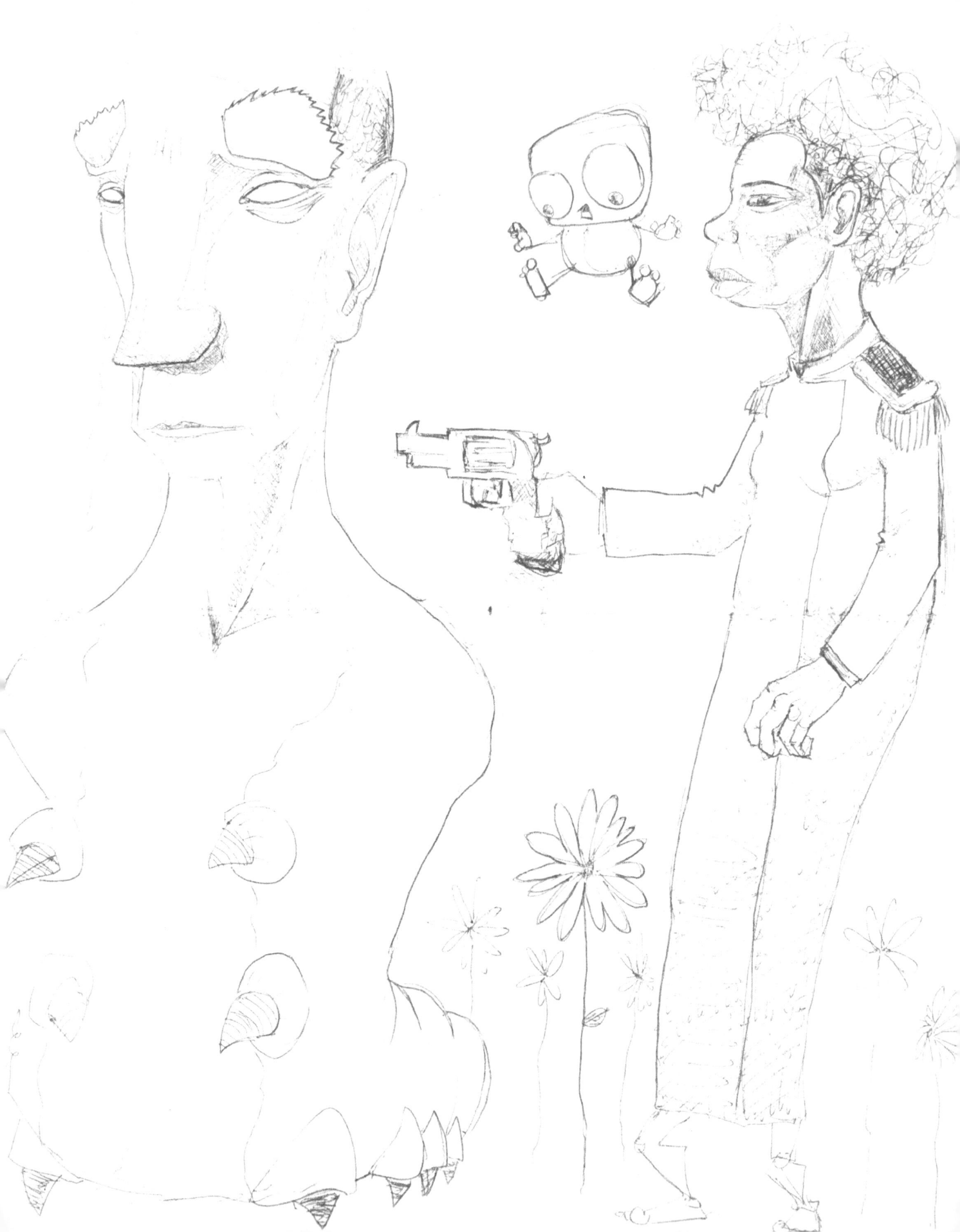

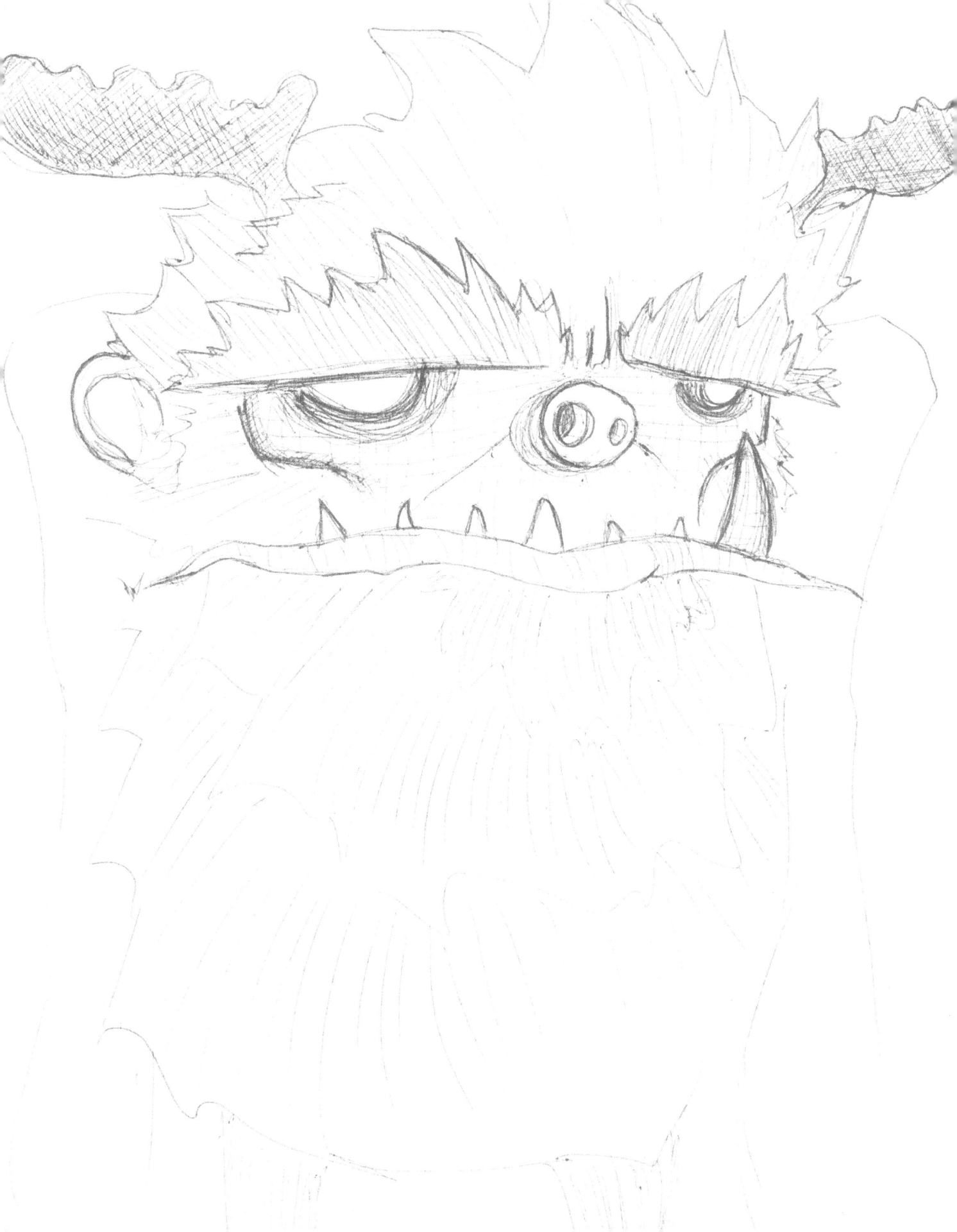

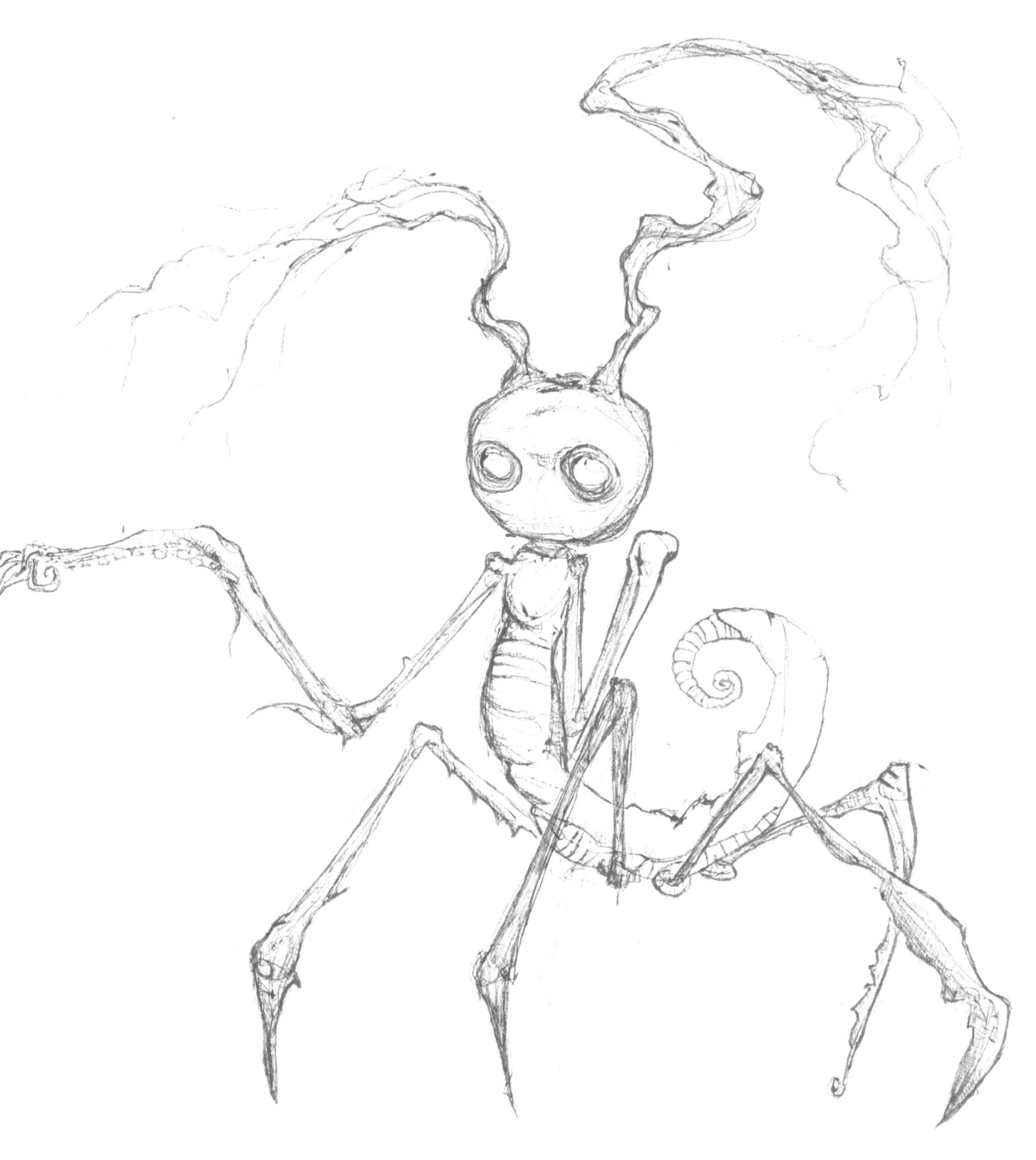

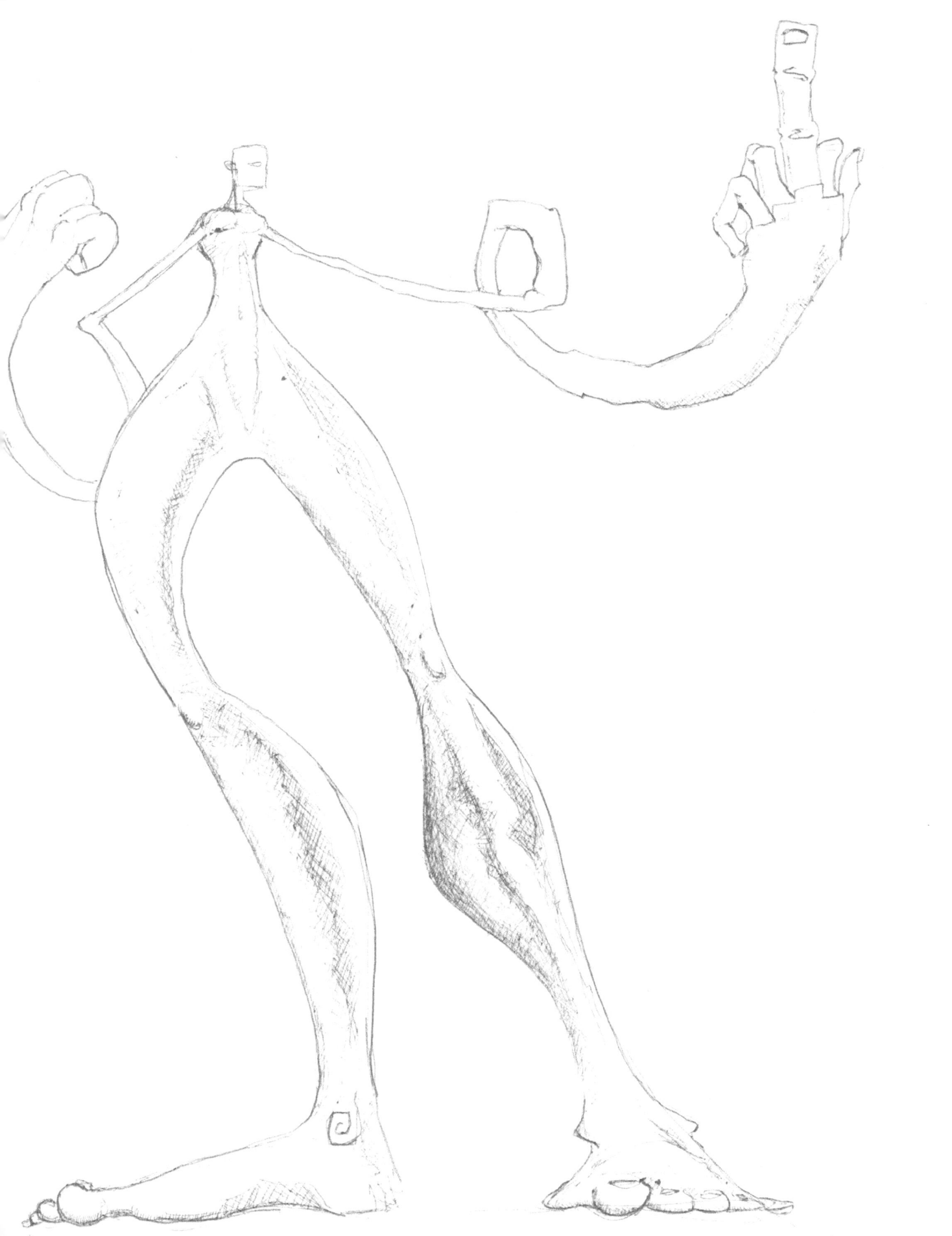

25

www.ingramcontent.com/pod-product-compliance
Lightning Source LLC
Chambersburg PA
CBHW050740180526
45159CB00003B/1295